Intentism: *Public Debates 2009- 2011*

Intentism: *Public Debates 2009-2012*

Edited by Vittorio Pelosi

Intentism Publishing House

Intentism Publishing House

First published 2016

All rights reserved. No part of this publication may be reproduced, stored in a retrieval system, or transmitted, in any form or by any means, electronic, mechanical, photocopying, recording, or otherwise, without the prior written permission of Intentism Publishing House, (Intentism@gmail.com) with the sole exception of photocopying carried out under the conditions described below.

This book is sold subject to the condition that it shall not, by way of trade or otherwise, be lent, resold, hired out, or circulated without the publisher's prior consent in any form of binding or cover other than that in which it is published and without a similar condition including this condition being imposed on the subsequent purchaser.

Photocopying

The publisher grants permission for photocopying according to the following conditions. Individual purchasers may make copies for their own use or for classes they teach. School purchasers may make copies for the use of their staff and students, but this permission does not extend to additional schools or branches.

In no circumstances may any part of this book be photocopied for resale.

Contents

Panel debate on Intentism at Chelsea College of Arts. University of the Arts, London 2009. **P.11**

Speakers:

Vittorio Pelosi, visual artist and Founder of Intentism.

Stephen Carter (at the time) Head of Painting, Central Saint Martins, UAL

Professor Paisley Livingston, Chair Professor and Head of Department of Philosophy, Lingham University, Hong Kong

Panel debate on Intentism and intentionalism at The Royal College of Arts, London 2012. **P.49**

Speakers:

Vittorio Pelosi, visual artist and Founder of Intentism.

Professor John Sutherland Emeritus Lord Northcliffe Professor of Modern English Literature at University College London.

George Szirtes, British poet.

Preface

In the spring of 2009 The University of the Arts annual alumni event hosted a debate on a new arts movement that was founded by an ex-student of Central Saint Martins: Vittorio Pelosi.

The debate garnered much publicity as it discussed authorship and intention; themes that Western art schools had considered dead and buried subjects.

By 2011 the matter of authorial intent had become sufficiently significant that The Royal College of Art was the location for a debate on intentionalism and Intentism hosted by The Battle of Ideas.

These are the panel debates in their entirety. The only editing has been to make occasional unclear audio intelligible.

Editor's Note:

The publication of these two seminal debates is the result of video transcription. Therefore, although great care has been taken to be as accurate as possible, inevitably there will be omissions when the sound quality made this impossible. For this the editor can only apologize.

Panel Debate at Chelsea School of Art

Speakers:

Vittorio Pelosi

Having studied at Central Saint Martins, Vittorio became the most prolific and one of the most successful society portrait painters of the noughties painting many from the stage, screen, music and television- including astronomer Sir Patrick Moore and Strictly host Tess Daly.

Vittorio and his art have appeared on BBC2 and ITV1 and his exhibtions have been shown in The Independent newspaper amongst others.

In 2009 Vittorio founded the arts movement Intentism. Intentists believe that all meaning is the imperfect outworking of Intention.

Stephen Carter

Stephen Carter was born in Kingston-upon-Thames, England in 1949. He studied fine art at Canterbury College of Art and Birmingham College of art, completing post graduate studies in painting in 1972

At the time of the debate, Stephen was Head of Third Year Painting, Central Saint Martins, UAL.

Professor Paisley Livingston

Paisley Livingston is Chair Professor and Head of Department of Philosophy, Lingham University, Hong Kong. Specializing in Aesthetics and epistemology, at the time of writing he has published nine books including 'Art and Intention' and dozens of articles many on the subject of intentionalism.

Chelsea School Representative: Welcome everybody and thank you for coming to our Panel discussion this afternoon: The arts and intention: The death of the author. I'm going to pass you over to our chair now, Mr. Luciano Pelosi but I would like to welcome our speakers for this afternoon. Thank you.

Luciano Pelosi: Thank you very much for coming. My name is Luciano and we have three speakers today. For this particular session the first half of it will comprise of three talks, ten minutes each and then we'll have a chance to debate and you'll have a chance to ask your questions and make your thoughts known to the rest of us so that we can have hopefully what will be quite a lively discussion on intention and art. Let me just introduce the three speakers today. We have Vittorio Pelosi to my left here. He's a founding Intentist and an ex- Central Saint Martins' student so he belongs to the alumni there and he'll be giving the initial talk on Intentism: The Resurrection of the Artist. Following him will be Stephen Carter, Principal lecturer of Fine Art. This is Stephen Carter at the end here. He's Principal lecturer of Fine Arts at Byam Shaw School of Art which is part of Central Saint Martins. Finally, we will have Professor Paisley Livingston in the middle and he's author of a book called Art and Intention and he's also a professor of philosophy. Right. Well, let us begin with Vittorio Pelosi's ten minute talk on art and intention: Intentism, the Resurrection of the Artist.

Vittorio Pelosi: Thank you. Okay. Intentism and the Resurrection of the Artist. I just want to give you a brief story of something that might get you thinking. In 1878 John Ruskin, the well-known art critic called Whistler's work,"slapdash and uninformed." Now Whistler was incensed by this and he took him to court. William Rossetti who was Whistler's defendant at the time said this "The art critic should always bear in mind the artist's intentions and Whistler was successful in his intentions." The question I want to ask you today is would you agree with Rossetti's statement that we should always take on board the artists' intentions? I want to start off by looking at four main figures that have been involved in a lot of this argument and the process of deciding whether intention is important or not. The first two people are called Beardley and Wimsatt and they've written something very, very famous called 'The Intentional Fallacy.' It was written in 1946 and they said this, "The design or intention of the author is neither available nor desirable as a standard for judging the success of a work of literary art." Okay so you don't desire it, you don't need it and you can't even get it. The second

person is a famous French philosopher called Roland Barthes and he spoke about the death of the author in a seminal work in 1967 and he wrote that works are a, "tissue of quotations," and the meaning of a text is in the impression on the reader. So the meaning is not in the work, it's in the impression on the reader when you look at it- hence the, "birth of the viewer." The viewer is made alive, and the author dies.

Okay number three. Somebody called Jacques Derrida. We've all heard of him and obviously one of the things he's very famous for is deconstruction. A chief element of this is to look at the work and try to see where there might be contradictory meanings inside the work that almost certainly the author didn't intend but they are there by deconstructing the text. Lastly, a gentleman whose name is Gadamer and he spoke of, "the effective history of the work." What he meant by this is the work can change it's meaning over time through maybe different things that happen in society or culture or different people who look at it, the work can change its meaning. I want us very briefly to have a look at this and remember that art has very often been at the vanguard of new ideas and new thinking. However, some of these ideas are pretty old. Now this is not to say that they are consequently wrong, but we shouldn't put them up on a pedestal and say we're afraid to judge them and critique them. So that's hopefully what we're going to do today.

The first thing I want to look at is a study called 'Piss Christ' by Andres Serrano. Now some of you might find it interesting, some of you might find it offensive but what's important is this photograph of a small plastic crucifix in the artist's urine obviously caused a lot of anger, particularly in middle America, and the Senators Jesse Helms and Al D'Amato were outraged. They had a big debate on it. What's of note is that none of the debate focused on whether the work looked like anything in particular, the materials that were used or anything like that. What was debated was the intention of the author or the artist. Serrano said that Christianity has a lot to do with bodily fluids. Think about the Last Supper, 'this is my body', 'this is my blood' with the bread and the wine; think of the crucifixion when Jesus dies on the cross and blood and water drips from his sides as the Centurion pierces his side. There is a great deal about bodily fluids and he was saying that's what it meant. He argued successfully that it wasn't anything in any way offensive to Christianity and the work remained in the gallery.

Inconsistencies.

Heidegger, Paul De Man and Nazism. Derrida and Searle.

I just want to get you thinking about some difficulties particularly in living a life consistent with the belief that the author has died. First of all, Heidegger was one of the greatest influencers on all of this. He was a National Socialist and I just want to give you a quote. Heidegger said," I know I ought to decide to work at the task that best serves my work for Adolf Hitler." That was one of the quotes that he made in 1933. The question I want to ask though is not whether that's offensive or not, the question is if you believe in the death of the author then what's the big deal about a quote such as this? Surely we should say that's his viewpoint but I'm interested in his philosophy and since the author has died, his personal beliefs do not affect his philosophical writings and yet many of the people who advocate these ideas on the death of the author were shocked. Many thought how can I look at his ideas particularly about morality when he believes this?

Secondly, Paul De Man wrote one hundred and seventy pro-Nazi articles. Again, what's the problem if the author has died? Lastly, John Searle, an American philosopher challenged Derrida about a point that he made and Derrida responded by writing a ninety-three page response to him. Now this is the most interesting thing: Derrida who's the champion of deconstruction said that what he meant should have been clear to Searle. That's one of his points in the ninety three pages.

Intentism: A Definition

Who are we? Intentism is a movement of artists, authors and musicians who believe that art can convey an artist's intended message to his or her intended audience. As a movement it both recognizes and celebrates a relationship between an artist's creation and its creator. Intentists believe that "All meaning is the imperfect outworking of intention." This is to say that meaning and the work are not the same. We're not saying that intention equals meaning but we're saying meaning is the physical outworking of mental intention.

Intention:

1. **Intention is not always conscious**
2. **Causes and Intention: a focus on causes.**

Firstly, intention is not always conscious. Let me give you an example. People may argue that you misunderstood a text or a work because when someone writes something they don't understand all the complexities of their mind so how do they truly know what they're writing about? Well, Intentists would say- okay, we've got to break this down a little bit because intention is not always conscious. Think of a great pianist who's maybe playing something like a Rubenstein movement and he intends to play that and he does play it but he's not aware of every movement of his finger. Again, when a footballer plays he or she may not be aware of every movement of their body when they kick a ball but it's still intention even though it's unconscious.

Secondly, causes and intention. Now this is something slightly different as well. Say, for want of a better example, Adolf Hitler's desire to exterminate the Jews. Now that may be based partly on some horrific experience of violence when he was a child that might have caused him to be muddled in his thinking about death but that we wouldn't say is the same thing as intention. He didn't intend the death of millions of Jews as a response to a childhood incident. No, that's a "cause." Adolf Hitler may not be aware of the meanings and all the complexities of the cause but his intention is still a desire to exterminate Jews. It doesn't muddle that, it's something slightly different and Intentists want to uphold both cause and intention.

3. **The work is the 'vehicle' for the meaning.**
4. **Meaning and Significance. Uplifting meaning and significance.**

The work is the vehicle for the meeting. This is important to distinguish and we'll have a look at that in a moment. Fourthly, Intentists want to uplift and uphold meaning and significance as they are slightly different. Again we'll have a look at that next.

Case Studies

1. The Shaftesbury Memorial

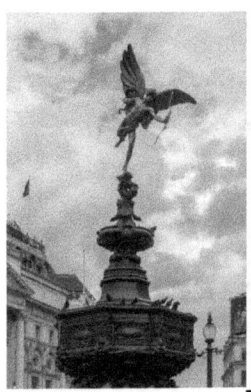

We've got some case studies. First of all the Shaftesbury Memorial. Think that you're in a pop quiz and this sculpture is shown and the question is "what's the name of the work?" Of course, everybody says I know, I've been there numerous occasions that's the statue of Eros in Piccadilly, London. Well, it actually isn't. It's actually of his brother Anteros -the god of selfless love. This is what the government asked the artist Alfred Gilbert to produce and that's what he produced. So the majority believe it's Eros but the majority doesn't make the meaning. That meaning is Anteros, but the significance for the majority of people is Eros. We should not undermine significances since art has the capacity to speak to people in different ways and we should celebrate the significances but still distinguish it from meaning. Alternatively, think of when you hear a lovely song and you say to your wife," that's our song." Did the writer really write about you when he was penning this song? No, of course he didn't but it's a joyous and wonderful thing that you can associate the songwriter's expressions of love with your relationship. However, again that's significance and not meaning.

2. Che Guevara

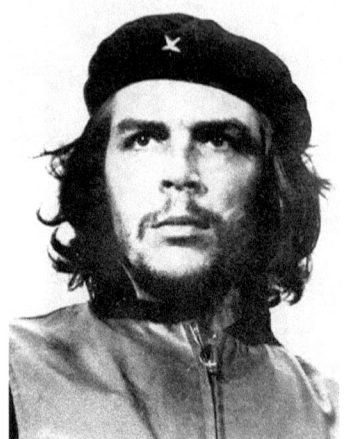 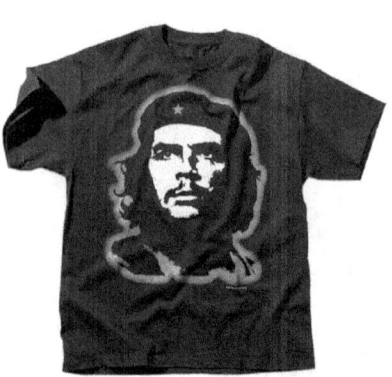

Think about Che Guevara. The first image was a photograph taken of him at a funeral, a very solemn occasion. The second reflects the appropriation of his image to reflect fashion. It's about coolness; it's about Camden Market. However, the first image is still concerned with solemnity even if in hindsight we can place other significances on it. The new image as a new artwork however, can give new meaning. Intentists simplify this by saying,' No creative input, no meaning input.'

3. Child Art

Think of a child's drawing of his mother. Now what if the mother came up to the child and asked what the picture was of and the child said,' it's of you'? What if the mother disagreed and told the child is was actually a monster. That might be quite hurtful for a young child. Therefore, the meaning is the mother even though the vehicle (we're saying they are different) is terrible and you may need to get him to go to art school and learn how to draw more accurately.

In this example the intention was unsuccessfully communicated. I would say it's an unsuccessful intention because he hasn't been able to communicate the image of his mother but the meeting is still the mother even though the intention is unsuccessfully communicated.

Common questions.

1. **What about accident?**
2. **What about irony?**
3. **Isn't intention impossible to discover?**

What about accident? Okay, well we've said today that the unconscious is still involved with intention. The opposite of intention is accident. However, intention is still inescapable, even here. How do you know it's an accident unless you compare that with the original intentions? You're still going to be involved with thinking about intention. Furthermore, what if you make a mistake and you decide to include that in the work and not get rid of it? Well, that's still intention. Through the editing it's still intention.

Secondly, what about irony? Wel,l the same point can be raised again. You only know if something's ironic or sarcastic if you relate that to what you think the person's intention is.

Thirdly, isn't intention impossible to discover? Well it is difficult and people will say it's very, very hard. I agree with them. But we've got to first of all decide whether it's important to meaning. If it is we've got to try and work it out and there are places to go. First of all, you can look at the work, you can look at its genre, you can look at the previous work of the artist, you can look at sketchbooks, and you can look at interviews- so it's not impossible.

Palimpsestism

Celebrating the Creative Trail

The last section then very briefly is how all this this is manifest in the work. Intentists talk about 'Palimpsestism' which basically means showing in your work the trace of your creative journey or the 'creative trail.' So if you have a look at a detail of my painting 'The School of Postmodernism' we're not afraid of keeping some reference to our mistakes, our edits. Many artists like to hide their creative journey from the finished work. We celebrate it because we're intrigued by how the editing and the intentional journey works. So, here you've got an earlier part of the face just to the right: I have painted over it, but it's still there.

Another concern for artists is that we should not be gagged. It is all very well saying that sometimes an artist wants his work to have multiple levels and be deliberately ambiguous, it's another thing to be told that theory makes it impossible to communicate an idea or message clearly. Now we believe an artist can say something and can be understood. So a lot of our art is quite polemical. This is illustrated in this painting. The blade is polemical about knife crime because we believe that artists can be pioneers in society and actually make an impact and have an effect.

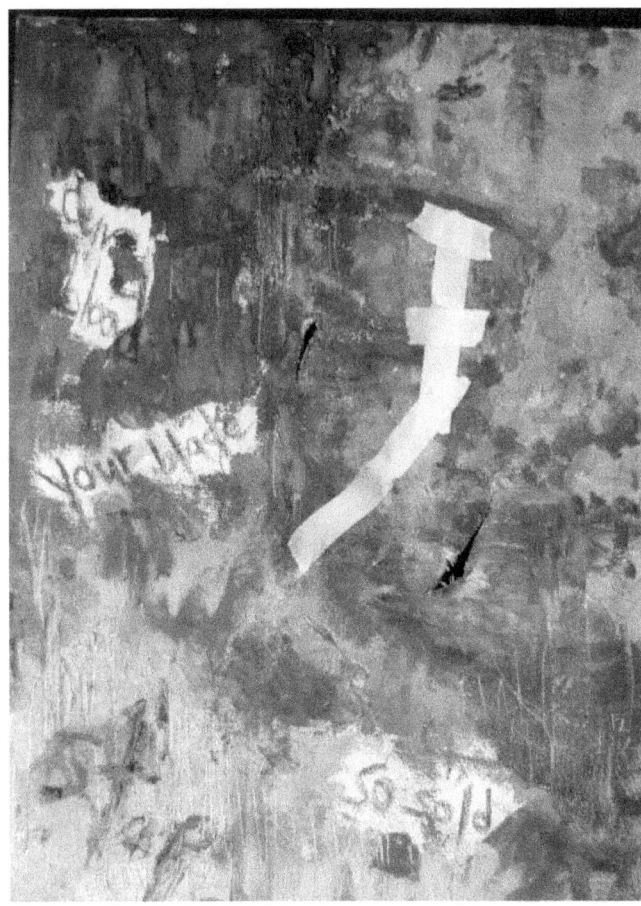

Next poetry. Again we often keep this creative trail in the work. This here is basically the work in progress, the trail of this poem. So you've got all the stuff that's been said, all these edits in the work.

Park

I lay around, dazed, immune to the world.
Yet, it reaches out to me, unbending.
Choking, I sit up.
Heavenward.
Which way to the world?
Bright eyes? She teases. I turn – I must.
A discarded note.
I choke.

I turn, I must. A discarded note. I choke.

She plays, she teases. I turn – I must.
I look towards my watch, counting.

Bright eyes? She plays, she jumps, she

Choking, I sit up, heavenward.
Which way to the world?
Bright eyes?
I supplant my attention on the girl in the park

I lay around, dazed, immune to the world.
Yet it reaches out to me. Unbending. I choke

Vittorio Pelosi 2009

However, I must say something at this point. We don't just engage in the process- perhaps like some of abstract expressionism. We still believe something is final and complete so that there is a finished work.

We have said, "the last intention of the artist to intend no more" and then the work is complete and all the epistemological qualities of the work are present.

This other example shows the creative trail in parenthesis. Or you might have the idea of bracketed work through using commas- a little like non-defining relative clauses.

Grind

((Sitting on a train.
Weakened by the weather, (it's) gormless, overshadowed by snippets from last night's dream,
Of love rejected.))
Slumped on a tube seat,
My head rattling against the casement window,
My stomach in knots,
(The power of 8,000 atoms)
(Still dreaming)
Having dreamt about a (girl) vision who left me six years ago....
(Again).
And now, only waiting for tonight...
To wash away the lemon (traces) grinds of the night before.

Gideon Parry 2009

So final thoughts. We believe a lot of postmodernism is very good. It helps us to not think that somehow the art author is a god but we need to not be afraid of critiquing it and, if necessary, moving onwards. Today is Independence Day in The States. Let's liberate the artist. Let's say we believe he or she can speak and be able to be understood and communicate what he or she believes in his or her work.

Speaker 2: Stephen Carter

Luciano Pelosi: Right. The next speaker is Stephen Carter. Those of you who just arrived Stephen Carter is principal lecturer of Fine Art at Byam Shaw School of Art, part of Central Saint Martins and he will be looking at another perspective of intention in art.

Stephen Carter: Thank you. So I'm not sure if I'm arguing against Vittorio or complimenting him or just coming from a different angle but what I try to do really is to think about three questions that were put forward to me to respond to. I'll outline what the questions are: the first one is whether an artist's intention influences the way people understand the artist's work. The second one is if an artist is free to act upon intentions and to visualize ideas. And the third question relates to the essay of Roland Barthes that Vittorio's just referred to namely 'The Death of the Author' which is contained in this book, 'Image, Music, Text' which incidentally I bought in 1996. I notice the year because I write the dates when I by my books so I'm reflecting on something that I read in 1996 again. So let's come back to the first question, should an artist's intention influence the way people understand the artist's work? A nice sort of response to that is that inevitably it will if it's known but of course it then poses the question: do we know and how do we know?

So assuming that the artist is still alive and assuming that we could actually meet the artist then we could talk to the artist and we could ask the artist questions. They would tell us things so we would naturally think 'right, I really want to know what your intention is when you made this piece of work that I'm now regarding.' However, there could still be a problem even if we were privileged to have this sort of one-to-one interview with the artist and ask him or her all the questions that we wanted to. There could be a problem because the problem could be that this person might be dishonest. Secondly, there could be another problem that actually they may only be dimly aware of what they're actually engaged with themselves. Furthermore, there could be another problem. They're not dishonest but they actually are quite secretive and they feel that part of this thing that they've made, this thing we call 'art' is it's mysteriousness and therefore the last thing they want to do is to be clear with you about their intentions because

mystification to them is actually part of what art is and the best art is that which is the most opaque they might say. So there could be a number of problems here.

On the other hand, you know there are certain things that we're aware of that have been passed on to us. So I can think of Mark Rothko for example, who said that he didn't want you to talk about color when you looked at his painting, he wanted you to cry. I don't know whether he really said this or not or whether it's an anecdote. Furthermore, there are all sorts of things that I think Picasso said which give me some kind of insight into his intention. For example, there's the story that Picasso was in a restaurant one time and it came to paying the bill. It was a really good restaurant and he didn't have any money. So it was a slightly embarrassing situation. The manager comes over and starts getting angry about it. So the customer says, "well I'm an artist" and the manager says," well okay, you know I do actually collect art. So I'll tell you what, you give me a piece of your art and then you don't have to pay the bill." And Picasso looks at him and frowns and he says," you want a piece of my art? Well, I don't want to buy your business, I just want to pay my bill." So these stories tell us something about the intention of the artist but in a kind of an elliptical way, not in a way that is actually really explaining anything. If true, what does this story tell us? It tells us that Picasso had a high regard for himself maybe or for his own abilities or for a recognition that if his works weren't worth millions at the time, that they would be in the future.

So in other words the question hangs in the air: What do we know about an artist's intention through their own spoken comment, through written comments, through comments that have been passed down to us over a period of time? But I think the other aspect of what Vittorio's talking about as I understand it is the question of what I would call responsibility. So from my point of view - and this is another anecdote which may or may not be true about an artist - is a story about Kenneth Noland, the abstract American artist who was very active and very much talked about in the late sixties and through the seventies and is largely forgotten about now as it happens but may be remembered again in the future. And he's been interviewed about his work and he's been asked the question and he says, "don't ask me, ask Clem." What does that mean? What it means is that Clement Greenberg, the great American critic is the person to ask about his intentions about the meanings of the work that he's producing. At this point what we get is a terrible cop out and it's irresponsible but also what it is is the kind of culture that

arguably we have now whereby if the B.B.C. are organizing a panel discussion about visual arts, they will not invite a visual artist to comment on visual art. Why not? Because visual artists just do it, don't they? Other people comment on it so we'll invite somebody who's a literary expert or anybody. Somebody who's a celebrity. Let's have a pop star. They can talk about art. Who should we have on the Turner Prize panel? Boy George maybe - that would be good and then we'll have Madonna to present it. In a way this is a terrible thing I think because what it implies is that visual artists are so wrapped up in their medium or that what they're doing is so mystified that they can't possibly articulate ideas about it in another language other than the visual - in other words in words which I think is an insult. So, listen up, B.B.C. I could be a commentator on pop music, and I'm a painter. Why shouldn't I be? I could be commenting on literature, on philosophy. I could be commenting on something I know very little about. I'm very happy to talk about anything you know, so why shouldn't I as an artist have that position of being invited to talk about things that I know nothing about? I think there should be some reciprocity there.

So to move on to the next question: is an artist free to act upon intentions and to visualize ideas? Here we get to the sort of post-structuralist aspect of it and leading into Roland Barthes and so on. To me it is relative. An artist does not have any freedom in a certain sense. There are artists who illustrate so if you like the idea, what they're going to illustrate has already been established. There's a certain freedom or latitude obviously in the interpretation or how that idea or that story is illustrated. I believe that very, very often we are doing things over again. We're not doing things first off, we're not original in that sense and obviously in other times and places it has been perfectly understood that an artist's role is not to be original but is to copy. What were those beautiful medieval manuscript drawings all about? They were about monks copying something that already existed over and over and over again. So the culture of the copy I think comes into play here. The artist's intention then is very clear. The artist's intention is to copy, to restate something that's already been stated. So I think that needs to be considered. It's as if artists need to explain their intentions as if we artists have anything new to say. Maybe we don't or maybe we don't want the burden of having anything new to say, we just want to say something over again because it needs to be said over again or in a new way perhaps.

Nevertheless I think the present circumstance is we have to really think about things being contingent. In other words, I don't think an artist now with any intelligence sets out to do anything which is definitive but rather sets out to make something which is contingent. That is maybe an intention or maybe it isn't an intention, maybe it's a sense of reality coming in.

The last issue. So to come back to dear old Roland Barthes and the Death of the Author, I think it's important to say there that he is referring to literature. Of course it would be very easy to say that what he's saying in that essay could be applied to any art form; to visual art, to music, to film theatre, etc. But I think one has to be a little bit careful about it. I think the key thing there which I think he's right about and I don't know you can really argue against, is that in his initial analysis of Balzac's novella he talks about a castrati - in other words a woman who is not, or may not be a woman but appears to be a woman and the commentary in the text is about the womanliness of this woman who isn't a woman. Now what Barthes asks in relation to that is: who is making this comment about the woman that isn't a woman? Is it Balzac himself? Is it the narrator? Is it the person, the character in the novel who is obsessed with this woman who isn't a woman? Or is it all of us who have this idea about gender and the authenticity of gender. And he leaves this sort of question hovering in the air, and I'm going to leave the question hovering in the air, and at that point he says that is the Death of the Author because this is not the author saying," This is what I think; this is the way I see things. This is the way; this is my vision." Instead it's up to us the reader to decide who is making this comment.

Chair: Thank you very much Stephen Carter. After Stephen we have as our third speaker Professor Paisley Livingston who is author of Art and Intention and a practicing Professor of Philosophy.

Speaker 3: Paisley Livingston

About Understanding a Work of Art: Examples and Questions

Paisley Livingston: Thank you. Well it's nice to be here and have this opportunity to discuss this. I just met Vittorio yesterday but he had contacted me when I was

in Hong Kong and I was delighted to learn that an energetic and talented young artist was engaging creatively with these kinds of issues about art making and intention that I've been working on for a long time in a more academic framework. It's an old debate between philosophers about intention and the relevance of intentions to the appreciation and understanding of works of art and but I think some of what I'll say will just be sort of backup for the points that he's been making. So about understanding a work of art, some examples and some questions.

A belated Neo-classism or a Neo-pop blend of irony and cynicism?

Jeff Koons, *Bourgeois Bust* (1991)

I teach in a small liberal arts college in Hong Kong and a lot of my students come to the philosophy of art with very little background particularly in European art and so I would show them a slide like this of a sculpture by Jeff Koons. In spite of the title they will start to try and talk about this as maybe an eighteenth century, genuinely neoclassical attempt at classical sculptural beauty. And so you should see their eyes open when I start telling them a little bit more about Jeff Koons and particularly the spouse ,who was the model for the right hand side of that sculptural work, Ilona Staller who has as you probably all know quite a notorious career as a member of the Italian parliament and before that a star in pornography. And so the more I tell them about Koons and his rather ironic neo-pop take on art and the world they really shift and re-categorize this and they no longer try to describe the 'level one' beautiful properties of this sculpture. So situating the art object (which Vittorio is calling the vehicle) - the artistic structure or object in whatever medium you know which is presented for the perception of the public- situating that object and talking about it as a work of art requires a certain kind of contextual background knowledge. Part of that background knowledge can simply be the intentions of the artist. So is this belated Neo-classicism or a Neo-pop blend of irony and cynicism? Obviously I think we can argue on fairly good grounds for the latter and not the former with reference to that example.

An Escheresque Formalism, or a Political Statement based on Supernatural Tenets?

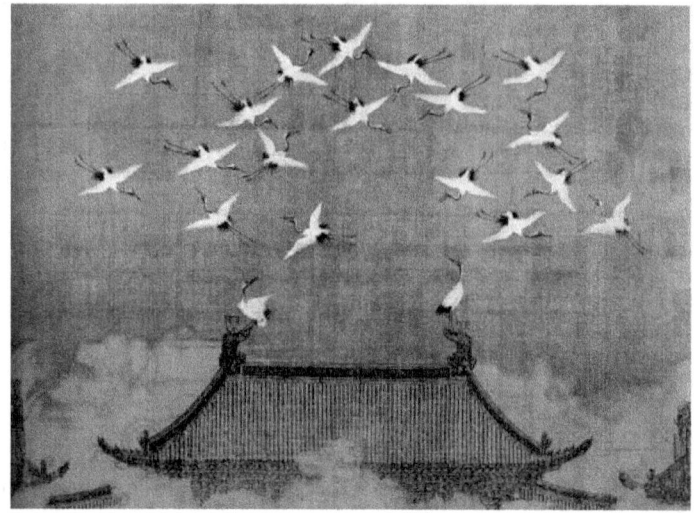

Zhao Ji [Huizong] *Auspicious Cranes* (1112)

Now let's take a look at an example of Chinese work. This is a very old work in the twelfth century and is part of a scroll and it's painted by the emperor of the Northern Song Dynasty. If you start to look at this you notice the lovely geometric pattern of the cranes that are hovering about in this kind of dance above the palace gate and you can contextualize it in a lot of different ways. You might start talking about the Escheresque geometrical configuration of the birds in flight but if you learn more about the historical Chinese context and the intentions of the Emperor this had a very heavily coded symbolic political signification. There's a Chinese category for what they call an 'auspicious sign' and this is a supernatural event that carries meaning to the community about the state of order or harmony in the kingdom and thus the quality of the leadership and this one picture that the Emperor himself painted was part of a huge series of visual works that were meant to show that everything was in order in the kingdom. So the alternative here is an Escheresque formalism or a political statement based on supernatural tenets? It's really the latter. Actually, things were not in order in the kingdom and

they were soon to be invaded and although this particular emperor was a very good artist, he was a very bad leader and wasn't paying much attention to what was going on and he actually was conquered and arrested.

An outrageous failure to render color naturally or playful experiment with pigment?

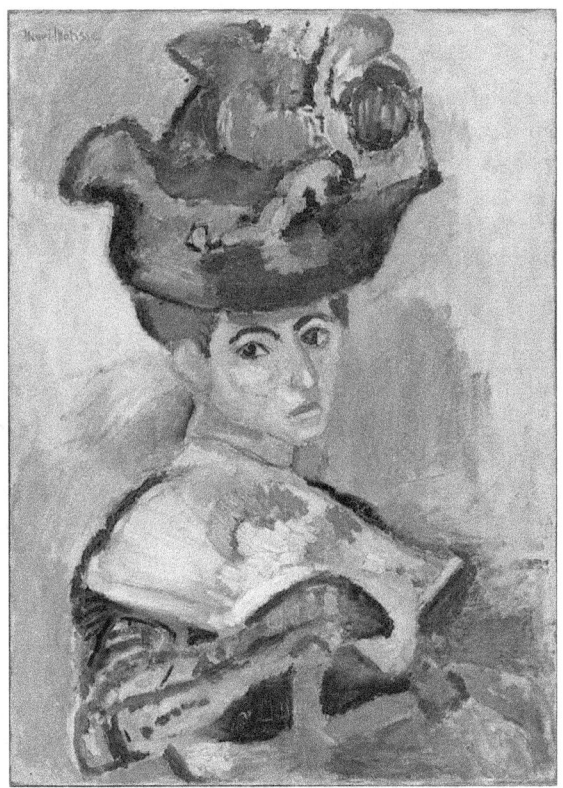

Henri Matisse, *Femme au chapeau* (1905)

Probably many of you are familiar with this, but this is 'Femme au chapeau' and of course there was public outrage, how could you do this with color? – 'Fauvism' – defined as 'wild beasts' you know, 'what do you think you're up to?' However, Matisse was very articulate about his desire to be free from some sort of realist convention in the use of color and instead adopting a playful use of color which

works in a certain kind of way. A lot of people, who, when they hear about the intentions that the author is giving, start to appreciate the interesting involved qualities of this in a new kind of way. So an outrageous failure to render color naturally, or playful experiment with pigment? Knowledge of the intentions and the context suggest strongly that we should look at it the latter way and not the former.

Some Truisms

- *the artist's intentions often make a difference to how a work turns out*
- *artistry, or the skilful accomplishment of artistic goals (by individual artists or groups of collaborating artists), is the source of one kind of artistic value*
- *appreciation of some artistic value requires uptake of the relevant intentions and intentional activities*

So some truisms. The artist's intentions, often not always, make a difference to how work turns out. Wouldn't the contrary be surprising? Secondly, artistry or the skillful accomplishment of artistic goals either by individual artists or groups of collaborating artists is a source of one kind of artistic value. I would really stress the 'one kind' but nonetheless it's important. Part of what we appreciate and enjoy in a great work is the skill with which this is being brought off, when it has been brought off in a skillful way.

Finally, appreciation of some artistic value requires uptake of the relevant intention and intentional activities. Again, this is true for some and not all value. I think, to step back briefly, this debate has been going on a long time. Vittorio gave some of the references from the 1940's but even before that you know Valerie writing in the early part of the twentieth century refers to what he calls the 'old question of the artist's intentions.' I could very briefly characterize the history of this debate as people taking really untenable extreme positions and then moving towards the center and that's where we are now. You rarely find anyone who is an absolutely dyed in the wool intentionalist who thinks that all of the meaning and value of the work is all and only that which was intended. That's a very hard view to defend but the other extreme position that intentions have

got nothing to do with it: the author is dead, it's just something completely inhuman; there aren't many people who really try to defend that anymore. So the more interesting questions are clustered around the mid zone. Maybe it's just because I'm Canadian but that's the kind of view that I defend, the kind of moderate sort of view.

What is an intention?

- *a complex representational mental attitude that includes content (some future action or actions the intending party is to perform) and motivation (the person is settled on performing the action)*

e.g. the emperor of the Northern Song dynasty intended to paint a scroll depicting an auspicious event ('ruiying') or magical sign of harmony in the kingdom

What is an intention? The book that I wrote on intention belabors this perhaps ad nauseum but I have chapters where I really unpack this question. But I think we can call intention a complex representational mental attitude that includes content, some future action or actions the intending party is to perform and motivation. We can say the person is settled on performing an action. If you have an intention to have dinner with a friend tonight you're settled on doing it you know. You might not end up doing it but there's some strong motivation leading you in that direction. So, for example, the Emperor of the Northern Song Dynasty intended to paint a scroll depicting an auspicious event. We don't know this for sure in some sense of absolute knowledge but what do we know you for sure in the sense of absolute knowledge? All I mean to say here is that all the evidence that we have, and there's quite a bit of evidence, points in the direction that he painted that scroll with that kind of intention.

What Intentionalism doesn't Entail

- *intentions are always conscious and deliberately formed*
- *intentions are infallible and always successful*
- *intentional artistry is the only source of artistic value*
- *all intentions are good intentions*
- *all intentions are known*

Vittorio has already said this, and we really have a marvelous kind of unintended convergence in what we are saying. Intentionalism doesn't entail that intentions are always conscious and deliberately formed. You don't have to intend to intend you know. You don't have to be some hyper-rational person from some science fiction story who is always in control of everything. Intentions just emerge spontaneously in our lives and we can act on them and they're not always the object of some sort of second order reflection - ponderous lucidity from someone who is hyper rational. You can have unconscious, spontaneous intention that guides actions. The best example for this is when you come home late and you have had a bit too much to drink and you routinely get your keys out of your pocket and unlock the doors so that you can go in go to bed. Do you consciously form the intention to reach in your pocket and get the key out? No, but it's an intentional action that you've performed.

Secondly, Intentionalism doesn't entail that intentions are infallible and always successful. We botch our intentions sometimes. We may have a project and not pull it off.

Thirdly, Intentionalism doesn't entail that intentional artistry is the only source of artistic value. Works have valuable meanings and properties that weren't intended by artists. That's the really good insight from anti-intentionalism. What I don't understand is why we can't conjoin that good idea with the good ideas from intentionalism.

Fourthly, intentionalism doesn't entail that all intentions are good intentions. This is obviously absurd.

Lastly, intentionalism doesn't entail that all intentions are known; obviously not. That's going to be my last point which I'll try to illustrate.

Puzzling intentions.

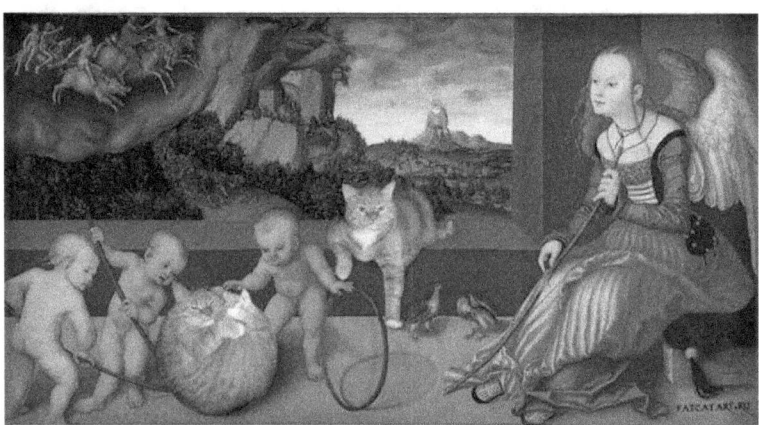

Lukas Cranach the Elder (1472-1553), *Melancholia* (1532)

This is a relatively small picture. I saw this in Copenhagen. It's at the National Gallery of Denmark in Copenhagen. There's another very similar small picture on the same theme somewhere in Germany but it's somewhat different.

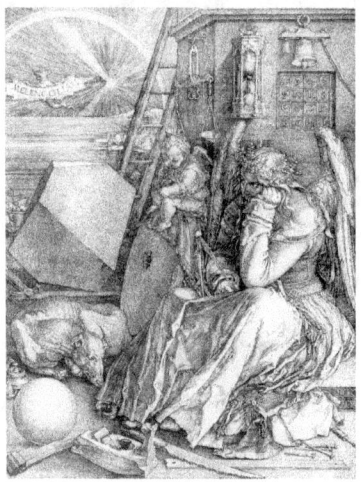

Albrecht Dürer, *Melecholia I*

This is a work by Albrecht Dürer called *Melecholia I* . This was a small engraving and was a source for Lukas Cranach the Elder's *Melancholia*. Cranach the Elder was trying to invent a new iconographical vocabulary for Protestants. However, of course because it was new it was mysterious because you have stable iconographic symbolism when you have a tradition that says the lily means one thing and so on so forth but the Protestants in trying to fashion their own new form of religious symbolism couldn't rely upon stable conventions of one-to-one semantic equivalence between a given depicted object and a certain kind of religious meaning. Consequently, you get these strange mysterious puzzling allegories. What are these Cupid figures trying to do there with that sphere in the foreground? They seem to be using these sticks to push it along in the direction of that hoop, but will it go through?

If you do a bit of measuring here with Photoshop you can find out that, in fact, as far as the visual input goes, the thing's too big and it's not going to go through that hoop.

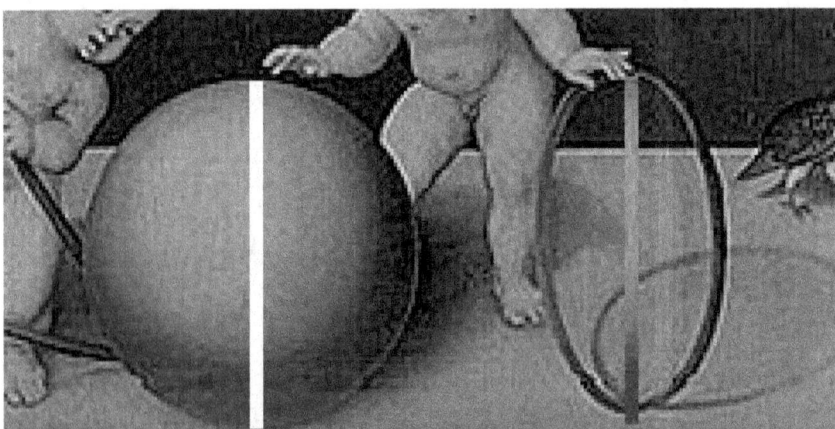

I'd take that to be an observable property of the depicted content of this picture that these Cupid figures are rolling a ball in the direction of a hoop and it looks like they're trying to roll it through the hoop but it's not going to fit. Intended or unintended? I have no idea.

It would be interesting to say Cranach and his people intended to make a picture in which the Cupid figures are trying to roll the ball through a hoop and they're trying to do something impossible. But I have no way to know. This confirms the point that Stephen made: sometimes we just don't know about intentions. Is this an unintended, amusing, semantic property of the work? Are the Cupids trying to do something that's impossible? If you give it a quick inattentive look you may not notice – you assume they're going to roll the ball over there and run it through the hoop. It's only if you start to study and realize wait a minute, that won't fit.

In summary, intentions determine some of the work's meaning and are crucial to apt appreciation, and awareness. Successful intentions promote understanding. Works have unintended meanings or significances. Thanks.

Panel Discussion

Chair: Thank you very much Professor Paisley Livingston. Hopefully some of those points will come up when we do the discussion. What will happen now is for slightly less than half an hour, we'd like to give you the opportunity to ask questions to any of the people on the panel here and also contribute your own thoughts. To shape things I think from what we've heard so far we have probably three broad areas. We have the area of the theory behind intention and art; the way it's been explained by each of the three speakers and how when we're looking at an artwork what role intention has in how we understand that art work. We've got the idea about how we use intention ourselves when we're painters or artists of different forms or sculptors and so this will be for practicing artists: how intention affects your art. And thirdly, the art movement Intentism that Vittorio mentioned earlier may provoke questions that you might have about that art movement. You want to know more about 'palimpsestism' - coming from a technique of re-writing over documents leaving layers of text. So ideas and questions related to the art movement. And so with that in mind, does anybody have a question that they'd like to bring to the panel? Can I have your question please?

Audience: Yes. I have a question regarding the theory of intention for Professor Livingston. I'm just wondering if you can't really know what this intention is, how do you know when artists are successful? Therefore, how do you measure an

artist's work? As an artist you're supposed to communicate something to the audience but maybe everything happens just by chance.

Livingston: That's a really good question and of course it's a hard question. I think the crux of that question are the words 'really know' because you've got high standards of knowledge and low standards and it's a kind of word game we can play. If you put the bar high enough, we don't know anything and you enter into skepticism. I can assure you that there is no successful philosophical refutation of Cartesian skepticism: for example, is the hand in front of my right now or not? If you say you know in the sense of absolutely with no logical possibility of error, you can't prove anything. You don't know anything but that's not the way we live. So then we use the word I 'know,' in the sense of," I know I'm going to do this," or ,"I know that next week this will happen." We use that word with lower standards. I think that's the whole question of judgment. When we talk about our historical claims or claims about contemporary art making, we have this problem of saying: what kind of standard of knowledge is relevant or fair or appropriate? I think on any kind of decent standard we do know artist's intentions. It's just not always. So the last bit there with Cranach was an example where I think that even with fairly low standards we don't really know. But I think with some of the other examples with moderate, reasonable standards of what counts as knowledge we do know. I do think we know about the intentions of the Emperor of the Northern Song Dynasty who made that scroll in the twelfth century. I do believe the historical reconstruction of the context is successful enough for us to say we know something real and important about his artistic intentions in painting that very beautiful scroll. So I don't know if that really helps but that's my way of going at that question.

Chair: Stephen do you have anything to add?

Carter: It's a bit naughty but I'll say it anyway. I guess does it matter? You know if you're making art yourself or if you're going to look at art or you know you're going to read something, don't you do it to enjoy it? Does it matter you know? Do you have to give yourself a headache over this thing? Do I have to give myself this headache and think what does the artist intend? I just like this and I don't like that. I'm consuming.

Chair: Vittorio?

Vittorio: Just a couple of things actually. One thing that Stephen said which I think is very useful early on in his presentation was when he spoke about Barthes. Obviously Barthes' Death of the Author was originally a commentary on literature and if I make a comment about literature first and then move on to the visual arts, I find it interesting that he would deconstruct things and pronounce the death of the author. However, mentioning what Paisley said about where we set the standard of knowing, in general communication it's interesting that we're actually generally surprised when we misinterpret someone's intention. It happens but we're surprised by it. So generally we expect their intention to be clear in the action that they go on to do. Secondly, moving on to visual work, I'm not saying it's always clear, I'm not saying we can always infallibly understand someone's intention: that'd be ludicrous, but I find it interesting that most of the ambiguous forms of art work that this whole debate is centered is based upon some form of intention. If you think about Duchamp's 'Fountain,' in what sense can we say that isn't just an object that become dislodged off the toilet somewhere? Isn't it based on what Duchamp was intending by it even if we never fully understand? I think that there are two issues here: whether we can understand the intention and whether it's important to know.

Chair: Would you like to come back on that or is there anything you'd like to say?

Audience: I was just wondering how you can measure an artistic work and maybe it's just a chance that somebody likes the work of the artist and that's why they become millionaires. Maybe it's down to chance and intention and something you can't really measure.

Chair: Thank you. All right next question.

Audience: An artist's decisions aren't necessarily conscious, they're more subconscious, aren't they?

Chair: Right. So if some of you weren't able to hear, this is about the role of the subconscious and intuitive behaviour in the creation of art and what does that have in terms of interplay with intention and meaning. Stephen, would you like to start?

Stephen: I think it's a very important question right now because it has to do with a culture that we have. There's a question in my mind about the degree to which

a research project for a visual artist can be credible. So for instance, you know the idea that somehow, retrospectively, you've got to self-consciously unpack what it is that you're putting into this work. Normally you wouldn't be doing that because you're working with whatever medium you're working with and the process of forming is at one with the process of thinking. However, research methodologies demand that these things are unpicked. So I think it's a very, very important question right now. I don't know what the answer is.

Chair: Thank you. Paisley, what would you like to say?

Paisley: I think that if you look at the testimony that we have from many great, creative people you always get a certain kind of picture that comes out and one really crucial part of that picture is that there is this thing that we call 'inspiration,' - there are different words for it. It's that bit when you wake up and there it is, you've got a thought that just pops into your head. You didn't rationally seek that out and deliberately get that idea. We call it 'popping' in psychology or in Ancient Greece it was like the Mad God taking over and speaking through you and that's the inspiration model. And this is part of the truth which is really important. However, if you take that too far it becomes impossible because at the same time, there's a lot of rational planning: you think about materials you need and you have to figure out how to get them and how to use them and there's a lot of this planning on how you're going to spend the time. Sometimes you don't feel particularly inspired but you know there are letters by Tchaikovsky saying you've got to make yourself work every day because if you don't those moments of that kind of graceful inspiration won't happen to you so you have to give yourself some kind of work-like discipline on a project. You need these kind of macro-schemes that you're going to do this and this and keep on plugging away even though if it's not very gratifying. It is the combination of all of these different moments that can be productive. So, there's no simple theory of creativity in art or elsewhere but the better testimony that I've seen stresses the different kinds of psychological and other processes that lead to those moments where something really interesting comes out. And by the way just on the other point I don't think intentionalism or intentism should be seen as a kind of totalizing theory of artistic value. You're not going to get that. There are too many different kinds of value, too many variables, too much uncertainty about it you know, so I don't think that's really within reach for us. It's not desirable. And what I wanted

to say was that intentions are part of the story of artistic value, part of that story, an important part but nobody has a viable, total theory of the many kinds of values of art. I don't see the interest of even looking for that.

Chair: Briefly Vittorio, you have anything to say?

Yes. Going back to this obviously very complicated and difficult question, the idea of the conscious and subconscious, what I wanted to the say is where the is value in deconstruction and the Death of the Author is in the idea of subconscious baggage through my culture, through the fact that I'm the age I am, I'm born in the time I was, I'm in the country I am in , I've the sexuality I have etc. , This leads me to think and behave in certain ways unconsciously including how I write or how I paint. If that's true, I think to a certain extent that is true, then that also applies to the view of the critic when they look at a work. They're going to bring the same unconscious baggage and the problem there is then if it can mean anything because I'm bringing unconscious baggage and the critic is bringing unconscious baggage, meaning is always indeterminate. If it can be anything then effectively it can be nothing. If my unconscious fits in some respect with my intention then I would say that the unconscious relates to the meaning of the work. So, going back to the concert pianist analogy- a musician is playing, unaware of what much of his hands are doing, but it's an unconscious thing that he does that makes him fulfill his intention of playing the piece. On the other hand, If the subconscious is contrary to the intention then I would say that's something slightly different. That would be some kind of 'cause', some kind of psychological cause that would be fascinating and very relevant in many ways but I would say it's less related to the meaning of the work than something that is unconscious but fits with the intention of the work.

Chair: We may have time for two more questions though, so what was your question?

Audience: I am intrigued by the whole discussion. When I have an idea that I want to express, it often just sits there waiting for the moment when I can create it. Suddenly I get the idea and I might wait some weeks for it. So, I have the intention I suppose at the back of my mind to create a poem or create a painting. When the spark happens I then start and I'm sure sometimes unconsciously I put secondary, third and fourth meanings in that I don't think of until perhaps I look

at the painting months later and I see that I've done something that I didn't perhaps intend but it just happened. I think part of the reason why all these things have happened is that I spent my life reading, thinking, analysing, and talking. So my question is where is the intention in that process?

Chair: Who would like to answer that one: where is the intention in what we just heard?

Vittorio: Let's start the ball rolling. I don't think anything you said has invalidated the idea of intention because you had an idea and that was your macro or meta-intention in thinking about something and coming up with an idea. Then you had the intention of waiting on it and letting it distill and try to get some of the ideas to progress. Finally, you did the work and you had various ideas that were conscious and then afterwards you looked back on it and noticed some of the unconscious intentions that you only then realized were manifest in the work.

Stephen: I think my response would be that we haven't used the word 'translation.' Because it seems to me that in underlying everything that's probably been said we may be looking at something visual but we're talking about it, we're using English language to talk about it. We tend to think that something's done but in order to understand it we've got to use words, we got to have writing. We've got to have explanations in writing or in words to help us to understand the intention and that's a translation. I would like to say that I've understood some things better, not necessarily through reading or having verbal explanations but because I perhaps have seen drawings that have gone into making a painting or I've seen photographs that have been sources for something else etc. or because I've seen a work in the process of evolution so I've seen it at an early stage and then a later stage and so on. I think it's very important that when we're talking about intention and how we understand intention that we don't fall into the trap of thinking that language, written language is always the only way of understanding anything.

Paisley: I thought what you said was very eloquent and made a lot of sense and that probably describes a lot of art making activity. What I would say is that what we need to do in the next step of the discussion would be to start to make some distinctions in different kinds of intentions. Sometimes what we mean is choices and decisions and unfortunately a lot of the discussion about whether artist

intentions make a difference or not is around only one sort of small kind of intention which is what philosophers would call a kind of very determinate semantic intention. In other words, if I put this pigment here that will mean X where X is some very precise, translatable, linguistic meaning and yes, there are intentions like that but you described a whole range of other kinds of intentions like the intention to be a poet and do poetry. These are called 'Categorical intentions' - I'm going to work in a particular genre or I'm going to use certain kinds of media or it's going to be comic or it's going to be serious or it's going to be evocative of this or that kind of emotion. You said you know some expressive intentions which might be quite nebulous in your mind and get worked out. So the macro-intentions are about the whole work. Micro-intentions are all these details. So I think 'Intentism' is a good label to start out with but of course as you work it out in detail it turns out there's a lot more to be said about different kinds of intentions and this theme of visual intentions which are properly visual and not translatable into articulate, linguistic, ideas.

Chair: We have time for one more question if anyone here has one more question.

Audience: On the subject of language. How do you feel about seeing gallery work on the wall with a massive amount of text next to it or a little story next to each piece of work? How do you feel about that?

Vittorio: I think that if it takes longer to read the explanation of the work than look at the work then I think that's obviously not a great sign. We said before that if you want the meaning of the work you need to look at the intention. However, an important point is the intention may not always be successful. I would suggest maybe the intention wasn't that successful if you've got to write a whole blurb about it. I think one thing as well to point out that's related to this is an argument about if you need to have information about a work, or not. The argument is as follows: Firstly, the meaning should be in the work. So, if the meaning's in the work and the intention wasn't successfully realized in the work then it's irrelevant to the work. However, if the intention was successful- it's in the work so why do we need to know about the intention? So perhaps they would suggest that you should never need any kind of accompanying text because it's all in the work. I think the Shaftesbury Memorial perhaps suggests that if you want to understand

the sculpture a little bit more, you might need to do something more than just look at the statue. So I think there is a valid place sometimes for text to understand the meaning of something but if there is page after page, maybe the intention was unsuccessfully realized in the work.

Stephen: I find this really interesting and the way I respond to this is to think of hybridization. In other words you know what we're getting is an impure experience. This is not a bad thing necessarily but we're actually getting an experience whereby we're looking at the art not as it might be but we're also reading what the curators are telling what we should be thinking . For example, how we should be interpreting or how we should be contextualizing this stuff that we're trying to come to terms with and often it is the curators rather than the artists - although sometimes they do have quotes from the artists.

Paisley: This is a big topic but I think that there's a distinction between the vehicle - the artistic structure which is that which is immediately perceptible and then the work of art. In some cases to get from the one to the other really does require a lot of other kinds of materials and background information - and in some cases text and so on. To get from a regular brillo box to Warhol you know, you need a lot. And so in cinema it's interesting now because you have people like Nolan and his brother who think that the work is actually the audio visual display that you might see screened or with a D.V.D. plus their website where they have all these other documents. Therefore, to understand Memento you need to visit the website and read these documents as well as immerse yourself in the linear audio visual display which you would have to watch from beginning to end at least twice or three times in order to start to penetrate a cryptic and puzzling thing like Memento. So it would seem to me wrong and prudish to say you can't make a work which is a conjunction of a website plus an audio visual display. What kind of conservative gesture would that be? Now when curators are trying to pull your gaze from the lovely picture over to a fairly tediously written thing which maybe is even wrong then I can see there could be a problem. The Tate Modern has got this Kandinsky and they have this text that says,' in the foreground there are two Cossacks and you can see their bright yellow hats,' but I defy you to find any Cossacks depicted in this abstract Kandinsky. This is just wrong. So if that's your worry, then I'm on board with that.

Chair: I'd like to thank Vittorio Pelosi for speaking and Stephen Carter for coming all this way to speak and Paisley Livingston for coming a very long way to give us some interesting thoughts about intention. I hope it stimulates your interest in intention, giving you great ideas for future art. Thank you so very much.

Panel Debate at The Royal College of Art

Speakers:

George Szirtes

He's a fine artist and a poet. His first book, The Slant Door, was published in 1979. It won the Geoffrey Faber Memorial Prize the following year.

He has won a variety of prizes for his work, most recently the 2004 T. S. Eliot Prize, for his collection Reel and the Bess Hokin Prize for poems in Poetry magazine, 2008. His translations from Hungarian poetry, fiction and drama have also won numerous awards.

Vittorio Pelosi

Having studied at Central Saint Martins, Vittorio became the most prolific and one of the most successful society portrait painters of the noughties painting many from the stage, screen, music and television- including astronomer Sir Patrick Moore and Strictly host Tess Daly.

Vittorio and his art have appeared on BBC2 and ITV1 and his exhibtions have been shown in The Independent newspaper amongst others.

In 2009 Vittorio founded the arts movement Intentism. Intentists believe that all meaning is the imperfect outworking of Intention.

Dolan Cummings

At the time of the debate Dolan was a member of the Institute of Ideas. He was editor of the online debating magazine Culture Wars and the editor of the book 'Debating Humanism.' Dolan is co-founder of the Manifesto Club.

John Sutherland

John Andrew Sutherland is a British academic, newspaper columnist and author. Currently he is an Emeritus Lord Northcliffe Professor of Modern English Literature at University College London. Apart from writing regularly for The Guardian newspaper, Sutherland has published over twenty books and has edited the Oxford Companion to Popular Fiction.

Chair: Welcome to the panel debate entitled 'The rebirth of the author?' I want to get straight into it but I have a small bit of an admission to make. Roland Barthes has long been on my list of 'nice men' – the sort of person you would like to have a cup of coffee with and a chat. He was unfortunately run over by a laundry van after a heavy lunch with President Mitterrand. I have re-read his classic essay 'Death of the Author.' I first read it 34 years ago and was very inspired by it as a statement of radical intent that the powerful, domineering influence of the author was now being challenged and the cannon was opened up to new interpretations. The Liberation of the Reader at the expense of the Death of the Author and at the time I thought that that was quite revolutionary and radical and liberating. Thirty four years later I think absolutely the opposite and I think that the Death of the Author is actually a quite dangerous essay in its attempt to kill off the human expressive subject, the author, and his ability to create a view of the world, trying to impart that view to us which we can then try and make sense of rather than giving up on the intent to try and make sense of it. This is because Barthes says in the essay that the removal of the author and the Death of the Author have two effects and I quote: one to render the claim to decipher a text quite futile and two, to amount to the death of the critic and therefore the death of judgement. Both things- criticism and judgement I think we need more than ever- not less. That's just where I'm coming from.

The inspiration for doing this session was actually down to Vittorio here on my left who has set up a movement called Intentism which wants to put intention not only on display in works of art but really back into an argument that will counter cultural relativism if you like, so hence a very important idea. So, thanks Vittorio for inspiring this session. However, let's introduce my panel and the order in which they are going to speak which will be quick introductions of about five minutes each in order to get into the discussion. On my right here is Dr George Szirtes and he's a fine artist and a poet. He's won numerous art prizes for his poetry and the TS Elliot prize in 2004. He's written about 14 books that are certainly worth looking at. He's a regular speaker at Battle of Ideas events so we're very glad to have him back. Again I know you have a very clear position on this, so it's great to have to you here.

The next speaker will be Vittorio as I mentioned who is also a fine artist, here to talk about literature and art here and the text and he's a very well-known portrait

painter and he set up the intentist movement to combat the prevailing modes of criticism in society which can discount and devalue an author's intent and he makes the point that art work should not be ashamed of its origin in the author and the human. Thank you for joining us Vittorio.

The third speaker will be Dolan Cummings, my former colleague at the Institute of Ideas. He's an associate fellow here and he actually published an essay that Vittorio wrote on intentism on 'Culture Wars' which would be worth reading if you haven't already. He's the editor of the book 'Debating Humanism' and he is co-founder of the Manifesto Club.

And last to speak on my far left is John Sutherland whom I'm very pleased was able to join us. I ran into John in a party this year. I managed to persuade him to come and do this. John is a very distinguished figure to be doing this debate. He is Emeritus Professor of Literature at the University College London, he's a regular columnist and author of the excellent 'How to Read a Novel.' I do hope it's in the bookshop. He's speaking later today as the Keynote speaker on 'Is Individualism Bad for Society?' but I know he'll have very fascinating insights on this too. Thank you, John.

George, your five minutes start now.

George: Can I give these out to the audience? I'll refer to them eventually. Well, thank you for inviting me. What I'm handing out is a copy of a poem. I don't have quite as firm an opinion on this as was said because the question of intentionality for example, is very, very complex. The idea of the Death of the Author was that the author releases the text and the text no longer belongs to him. A poet once said about his poems that he, 'let the little lyrical cripples walk on their own feet,' which is to say he was going to set them out and let them wander through the world and let them sort of look after themselves. He was not going to be the interpreter of his work. If however, you completely leave the text to itself and leave the completing in the hands of the reader and the reader does all the work, this is a kind of implication that almost any text would be okay because if the reader does the work you don't necessarily need a poet or an artist to produce material which expressly could be called art. However, works of art are constructed after a fashion. Of course Deconstruction which follows from the Death of the Author did some good things. It allowed people to read against text -

which people did anyway, but it also formalized their kind of response to say 'this is what the writer seems to be saying, but on the other hand, it seems to me that the writer's saying something else as well' and sometimes what the writer is saying or what the writer thinks he's saying is not what we think the writer's saying. Anybody who has had a book reviewed or under criticism will know that there are various opinions and it is not necessarily the case that you yourself as the author might have the best possible answer to these things. It's possible that at certain times a consensus of opinions for writers independent of the author could exercise a certain kind of authority.

Vittorio's going to talk about Intentism and I read his paper which is fascinating and I have ruled in sympathy with his ideas, in fact. However, what I'm slightly concerned about is his use, or his scope of the word 'intention.' What I have given to you is a poem. I'm not going to go into exegesis but let me first just take you through some of the potential complexities of the situation. It came from a sequence called: Flesh: An early family history, which was twenty-five poems divided into five sections and the theme was memory, but the first five poems are all about forgetting. All the poems in the twenty-five were five sections, each of those sections was written in 'terza rima.' All of that is part of the intention. It is also part of the intention to examine the idea of memory, of family anecdote or the reliability of recollection and so forth; all of that is very, very clear. Within this intention (which actually at the beginning I had no idea that there will be five sections of five- it was only after I'd written a couple that I thought I would add more) I'm thinking of individual things that I want to write about which are under the heading of the subject. One of the things I'm remembering is a 19th century book I had as a child in which the central character made a great impression on me. In this book, the central character having gone through several adventures wants to come back to his first love but he can't find it. Therefore, he takes shelter in the graveyard. The poem begins, "There is a graveyard, full moon and asleep a hero figure. " Easy enough. Then the poem continues, "Then at midnight ghosts in their thousands who are doomed to keep their appointments with the wide awake." Already there is a kind of mitigation of intention because of the demands of the language; let's just say I know I'm working within this form-means that I have to arrive at certain points. I have to have stanzas at certain points but there an intention is relatively clear. There is the subject. There's a mode. There's

a method. But the method is itself modifying the intention as it goes along. So far I know where I'm going. As the poem moves on, - there isn't time to take you through it- a series of ideas unfold. These ideas have intention, but there's tension in them. One, there's the original intention to refer to that moment to the sense of looking at the book as a child and trying to remember what it meant. On the other hand, there's this constant modification of it through what happens in language. So sometime in the middle of the book I'm now somewhere I don't exactly know. I know that there's something over there in the far horizon that my instinct says I'm trying to keep, but all the time I'm working through these modifications. So let me just draw your attention to the end of the poem. At the end of the poem it says, "ghosts in the graveyard wail to other moons." The stars have moved so far beyond the page -the stars that were on the illustration - they've gone right off the scale. Finally, there is this line, "small crumbs of icing in an empty jar." There was no intention at the beginning of the poem to produce that line or indeed to produce line 5 or line 6 or line 7. However, if you had questioned me, I wouldn't have known that. The only reason that line appears is because something needed to make a rhyme. That's how it works.

When you're working what you realize is that your intentional act is almost constantly an improvisation around the givens of language. So you finish up with your," small crumbs of icing in an empty jar" - a line that I've always loved and I stop the poem there. In other words, my intention is to stop the poem there and I do stop the poem there. But what I do know is that the engagement of material with language is an intrinsic part of the act and that I am not in control of the language, I cannot be completely in control of the language. I'm left constantly in a responding position. The pair of us: one self as the writer and the medium are in a kind of dance in which the writer cannot completely dictate. So, when somebody comes to the act of criticism, the critic who is faced with this will find it very, very hard to come back to a core which would then be called the writer's intention.

Thank you.

Vittorio: I speak to you today representing an international art movement which started in London called Intentism, a movement which explores and celebrates

the role of artistic intention by robustly defending the Intentist model for understanding the role of intention in art and by creating Intentist works.

The title of this debate 'Rebirth of the author' of course alludes to Roland Barthes 1967 essay The 'Death of the Author'. In this text Barthes asserted that 'writing is the destruction of every point of origin' and to 'give a text an author is to impose a limit on the text.' Barthes argument have parallels with other thinkers and movements that now dominate Anglo-American art schools with their shared conviction that works of art should be primarily understood by how minds receive them rather than by the human intentions that created them.

In this brief time I would like to look at two areas of theory that I believe are central to the debate: Firstly, The New Critics and texts, and secondly, Gadamar and the fine arts.

The New Critics Wimsatt and Beardsley's seminal essay 'The Intentional Fallacy' asserted two things that would influence Barthes. Texts have an independent status from the author and consequently the intention of the author is neither available nor desirable as a standard for judging a literary work's success.

It should be noted that according to Wimsatt and Beardsley, even living authors intentions are never available. Moreover, if we were able to know an author's explicit, comprehensive intentions, they would not be desirable. The meaning resides in the text alone.

However, if texts are independent from authors and the meaning does reside in the work alone then we shouldn't refer to it as if it were connected to the author in some way; for example Turner's work or Derrida's work. But we do, don't we? and interestingly so do Wimsatt, Beardsley and even Barthes. Furthermore, rejecting authorship would be to treat a landscape by Turner the same as we treat nature itself. We delight in both but we treat the artwork differently...why? Because we are recognising a mind behind it, we see it as a gesture formed through creative thinking or intention.

Any creative work is primarily a human gesture. A painting of nature is different from nature, an intentionally carved Stone age tool is different from a naturally sharp flint. The human intentional gesture imbues the object with meaning.

A further implication of these claims that were later developed by Barthes is that a text can semantically change over time. It is clear that over time people have used a word to mean different things. (eg. Wicked, gay etc.) It is the contention of the Intentists that when these words are brought together in a text, these words have a fixed meaning in space and time by the human gesture and that any later change is a change in significance, not meaning.

Secondly, a look at Gadamer, and the fine arts. Gadamer reasoned that works develop an 'effective history' as different cultures and peoples load new meanings. Influenced by Heidegger, Gadamer also emphasized the continuing narrative and baggage of our own lives. Since we are from a different place and time from the author, we can only understand when the two narratives happily meet; which he called the fusion of horizons. This narrative argument is very effective when interpreting texts since they clearly are narratorial and linear. We generally start and finish at the same place, reading letters and words sequentially. However, Barthes, Foucault and Derrida have all used their literary theories to understand fine art. Intentism as an arts movement argues that this theory overreaches itself. The reason is that many plastic arts such as painting, sculpture and photography are anarrative. There is no order of experience expectation in these art forms. Furthermore, there are no public rules that say an artist can't ignore perspective or colour theory in his work that parallel the public rules of language or genre. Without these public rules we can either echo Derrida that 'meaning is constantly deferred' or we need to know authorial intentions.

In conclusion, can it really be the case that when I speak to you now I can communicate with you – however imperfectly – but when I begin to write or paint I become suddenly dead to you? Can you really no longer hear me when I pick up a pen? Do you really only see your own reflections in every artwork; your own face in every portrait? Are you really hermetically sealed in this bubble that no artist can communicate with you through their art? Intentionalist sceptics would have us believe this. Thankfully the truth is much better news.

Let me finally quote again from the Intentist manifesto 'Intenstism is a movement of artists, authors and musicians who believe that works can convey the artist or author's intended message to his or her intended audience. Thankyou.

Dolan: I've put together some scattered thoughts. When I was at school in Glasgow one day in English class we had a workshop with Edward Morgan who was a Scottish Poet Laureate and died last year. He was gay and some of his work reflected that I suppose. There is a funny anecdote that he said to us that when he spoke in another school workshop where he read a particular poem one of the students had picked a particular line about a picnic, the story of a picnic. It says that 'two forks land together on the plate' and the student said," is it two forks because you're gay instead of a knife and fork?" and he said no. But that was quite interesting that somebody had thought about that. That was an example of someone reading something into the text that had not been intended and actually wasn't very profound. There are various example of when an author may not have thought about something at the time but we'll say "yes," but in this case it was just two forks because you don't really eat a strawberry with a knife and fork! I think that's the danger particularly when, say, someone is a gay author or a woman author or whatever and you think a sociological reading is right and that can sometimes impose on the writer in a way that isn't very helpful. It might be useful if you're a sociologist or historian. There's nothing wrong with doing that with really old texts and giving it an historical reading. I think it's important to make the distinction between a sociological or historical reading and a literary reading. A literary reading which is not just for literary scholars but for readers: those of us who read for pleasure and our own interest. But I also think it's important not to make a rigid distinction by saying something is not or has to be a literary reading.

For me the danger of focusing too much on the author's intent is that it can become biographical and 'what was the artist thinking?' or 'What was going on in their life at the time to make them think this?' and I think that often what we find interesting is the gap between the creator and the artifact. So it's interesting when George is talking about the text being independent of the author, which is an anti-intentist thing. However, I just see the traditional way of reading the text as being independent of the author not in a sociological sense but in the sense that the writer has created something which has merit on its own and so you know when you're reading Jane Austen for example, it's nice to know the historical background, the biographical data but that's not the point. They might ask you something that you completely miss because you didn't know because

you didn't know the historical background. For example, if you were reading Dante and you don't know about foreign politics in the thirteenth century then you'd be a bit confused, but it's not there to be read to understand those things. I think the danger is that the intentions of the author become biographical and that's an error. Later I will be speaking in a session on the King James Bibles and actually this is important not in terms of authorship. The Q'uran for Muslims is the word that God dictated to the Prophet Mohammed and the Bible even to Christians is inspired work written by several different authors and whether it is Moses who wrote the first five books or written by a collection of elders doesn't matter. It is something which comes together written by different authors and yet which has a singular meaning in the end. The Bible is an idea there's something there beyond the intentions of the author and I think perhaps that's the kind of drama that you were reading about but obviously Christians don't regard it as a work of literature primarily. To read it as a text not sociologically, not in a post modern sense but on its own terms means to see it as something beyond the author or authors. If we are really trying to find the meaning of the work itself, it helps to have biographical background but it should not take precedence over the work itself.

John: In cricket the tail ender is usually the weakest performer with the bat and that's how I feel. Everything I was going to say has been scooped with more forethought by Vittorio and often with more veracity and sensitivity by Dolan and George. So what I'd like just to use my five minutes for is to talk about what I'm doing at the moment which is reviewing a biography of Martin Amis. It's published, strictly embargo by the way until November the 3rd and it will be I think, a successful book but its publication has had rather a rocky road because the subject Martin Amis effectively repressed an earlier version of it. Now this book- and there's a description of it in today's Sunday Times by Richard Brooks who had a page 3 slot on the Sunday Times to deal with anything that is sensational and literary- this book is effectively and I choose the word carefully, about who Martin Amis fucked and it's a very impressive list I have to say. But at one point, about page 150, the author says, and he must be aware of the fact that he has drawn up a very long list of partners, there is a connection to be drawn between Martin's seductive technique and his fiction. Well I very much doubt that. In fact when you get to the end of this long list you may have felt that

it was a very free and easy time with the pill, and the 1960's was a very different period of moral anarchy. And it seems to me to be entirely beside the point because first of all if you feel soiled following this and then you try to find some kind of connection. It was Amis himself who said that Philip Roth in Portnoy's Complaint had taken the novel all the way from the bedroom to the bathroom and you do feel that literary criticism has turned into a gigantic keyhole. Another thing is that even though there is the occasional insight and this book actually does suggest that there was a trauma in his life that one of the people he was having an affair with hanged himself, but generally speaking it seems to me that the value of Amis' work is his voice. His extraordinary ability to throw his voice almost like a ventriloquist and in different characters. The novels of Martin Amis which are strongest are those which have this eloquence and that had nothing to do with the fact he was going to bed with people. Yet this biography will sell many, many more than one on narrative tone and voice in Amis' fiction. I feel there is an argument to be made for as it were, keeping the author out of the fray, and it goes beyond the sort of doctrines of intentionalism or Derrida's statement that there's nothing outside the text. Well there are lots of things outside the text- the world, for instance. However, it seems to me that if, in fact, we are dealing seriously with literature, there is an argument for the discipline to be like that of the intensive care unit and excluding extraneous things and focusing on what really matters- the word on the page. However, there is a kind of to and fro here regarding the reassertion of authorship and I have just published a book called Lives of the Novelists: A History of Fiction in 294 Lives. It seems to me that you have to kind of keep a sense of proportionality here. It's neither one or the other and intentionalism is a question of taste and judgement as many things in literary discussions are.

Chair: Okay, we thank our panel. Okay just two quick things from me before we go out to you. Vittorio, one question: you said, if I caught your 'intention' right, that the meaning of the text is fixed by the human gesture of the author at a moment in time and space. This means that that text is fixed and frozen but its significance culturally, historically may change over time. Is the implication of that then there is only one correct reading?

Vittorio: That's a very good question. I think that first we need to try and break down what we mean by 'reading'. I think that if you're talking about a text, we

need to work out what the intention of the author is in making that text and I think Speech Acts is a really good place to start. If your intention in that text is something like writing lyrics for a song or doing abstract paintings or something like that, I think then your intention may be something that's not so concrete in trying to communicate something to someone, but nevertheless I think that generally speaking I would say yes, to understand the meaning of the work is to understand the intention behind it. You can enjoy a book in multiple ways that may not include intention. However, we would say that would be to enjoy the book's multiple significances. Unfortunately this term coined by E.D.Hirsch Jnr sounds negative- particularly in the arts. What really happens – for example in music, is adoption- we adopt a song as our own. However, if you want to know the meaning of a song for example, a good place to start would be intention and yes, it would be one interpretation.

Chair: Okay let's open up that up. I guess I'm not entirely sure but I see it a bit more as a human gesture or that the author of the work expressing his view of the world in some way through art or literature, creating that view and packaging it up as a gift to the world and handing it over and then it might well be well-mannered for the author to retire from the room and not stare at you while you open your gift and unwrap it. So it's kind of necessity for the author to make himself a little bit irrelevant as you said John to back away and let the reader make what he thinks of it.

George: There's a very subtle distinction between meaning and significance and I think that's what so very hard to get hold of. There's something which I do; just a quick observation. The great growth of creative writing classes coincided with the time of the Death of Author, so everybody's trying to be the author heading towards death so to speak. There's a particular thing which I do, I read this Blake poem- 'The Sick Rose' to my students. There's always a nice little silence because nobody wants to say anything first. Then I say something ridiculous like, you know, it's about bicycles and of course you laugh and of course it's not about bicycles. So then you go on and say it's about gardening and they say no it's not about gardening. Little by little we begin to work down to a kind of interpretation of a reading, a series of possible leads. Now one of the other things we could do is to go back to Blake himself and to see the kind of things that he has done, the kind of things that he has said and therefore begin to interpret the poem in that

light. Now the question for me is, is there a final position that we could get to by that method and if we did get to a final position - this meaning, whether it would in some ways be a reduction of meaning? In so far as if the poem is simply realizing Blake's intentions and we can find out what those intentions are, have we therefore closed a book and we say 'yes, it's done with'? And I think we should be wary of doing that.

John: It seems to be a wonderful example to me of the words on the page approach. That whole lyric of 'The Sick Rose' which you recited, pivots on one word and that word is 'secret.' It is secrecy which is destroying the rose and it seems to me that the poem is totally explicable from its verbiage. Why in fact look beyond that perimeter.

Dolan: It occurs to me that I once witnessed an incredibly stupid argument about 9/11 discussing the description of 9/11 as 'tragic' and this person said no it doesn't fulfill the criteria as 'tragic' – it's actually 'comic' as it's a powerful thing that fallen down and so it's comic. And the argument went back and forth. Well, 9/11 was much more. Therefore, a literary reading of 9/11 is redundant. I think that that's important that for a work of art to be a work of art, there does have to be an intent. There does have to be an intention of an artist, something that is put out there. You could read anything, I mean that's one of the things about the Death of the Author that I do disagree with- that everything can be textual.

John: Why is one our greatest authors one of whom we know least about? So much so that I'm not even sure that Shakespeare is Shakespeare.

Chair: Ok. Let's open this up to the audience.

Audience member: I'd like to start by pointing out that once you publish a text or a painting or whatever you want to call it, the world starts editing it. So it also means that people whoare forced to see it, or read it also have an input on it and I also don't think that, are we really talking about the rebirth of the author because was he really dead to start with? Because the creative writing classes mentioned was a great example of how people still cultivated the author and how the way that bookshops and libraries are still organized very much around the author. So the author in itself or talking about the rebirth for me actually comes from a celebrity culture where we kind of cultivate the self like Byron. I think we should be using the term 'writer' or 'painter' and less the author.

Audience member: I want to speak about the intentionalist position regarding Blake. Not only does it reduce meaning, but it reduces the beauty of the poem. You reduce it and you take away all the magnificence of it and you're just saying, well what did Blake say? You know well if Blake just wanted to tell you something without beauty he would have just written it down and said 'this is my attitude to my love life.' He didn't, he gave us something that's magnificent and it's beautiful and its beauty is the fact that we engage with it not the fact that he's told us what to think.

Chair: Before we all gang up on Vittorio I think it is a question of balance. Had the balance not gone too far to the 'open', 'anything goes' and it needed to be reset so that Intentism is valuable in that respect. Secondly, you can't defeat Intentism's argument by just saying 'we don't know the mind of Blake or Homer because the position is that the meaning of the work is the 'outworking of the intention.' You don't pour the intention into the bucket of the text and there it is job done. The process of outworking is something that can get out of control so the intention becomes a different sort of intention in the end so there is some sort of subtlety to the argument.

Audience member: It's possible for the intention of somebody in any sphere of life to be not honest. So for instance, going to the 9/11 analogy you know about the people taking the action might have said it was about one thing, you viewing as an onlooker could look at it and say it was something else. For instance, maybe it was about the desire to be immortalized or to have meaning in your life rather than what they claimed it to be. In the same way Arthur Miller when he wrote the Crucible, although I think it's accepted the crucible is about McCarthyism, Arthur Miller said that at the time he wrote it he didn't actually know that it was about that and that he had a feeling of society moving in a direction that made him fearful but he didn't actually understand the process. He thought he was writing a book about the witchcraft fires although in hindsight he accepted that it was about McCarthyism. So I don't necessarily think that the intention is actually understood by the person and that there are various interpretations of that intention as well.

Sutherland: Yeah. I think that's a terribly good point. Look at Milton's great poem Paradise Lost – it was written to justify the ways of God to man. If you asked our

students after they've been reading Paradise Lost if they were better Christians, none of them would say yes. It wasn't that Milton misunderstood, it was that we choose to come at the poem at an entirely different angle that he would not have approved of.

Audience member: The thing that strikes me as somebody who has read novels and viewed paintings is that as Vittorio was saying, it is a creation; it is something that is created by man, it's not nature out there that you're just receiving, so to me it strikes me that it to a certain extent it is a conversation, that's probably not the right word for it but when I read something sometimes I get a meaning out of it, it touches me and I might want to explore it further. I might want to find out what the author's intention was and whether they've actually created that intention successfully in my mind. I might not want to do that, I might want to explore it in another way and I think what's really interesting is that sometimes when you are looking at things quite literally you might want to pull them apart I think, but you might just want to wallow in the ideas and how you received them and I don't think there's anything wrong with that. I mean one of the great things about this conference is that we all speak and you may really not understand the intention of what I was trying to say because I haven't put it very well or it may be that you thought you understood what I was going to say and that is the joy of art for me. So to kind of say we must know what the intention of the author is slightly scares me in a way although I agree with you that I don't like the idea that it is 'just how you receive it' because it is a conversation.

Chair: Vittorio, you have thirty seconds to come back.

Vittorio: Okay just a few things actually. One thing that Juhl wrote as one of the leading figures in the intentionalist debate was why when you look at a work that is unambiguous should we say that the meaning of that particular poem rests on that particular word and that we don't need the author- however, when we have something ambiguous we can say let's look into the intention of the author?. Why is it acceptable that we can break the hermeneutical rules with a whole new approach to interpretation when one text is ambiguous?

Secondly, the recent Shakespeare play 'Anonymous' to me is very interesting and it will be successful. Why? Because people are interested in who wrote

Shakespeare's plays. Why is Banksy successful? He makes good work, but not great work. Why is he a success? It is largely because of the question 'Who is he?'

Thirdly, if someone lies that doesn't mean there's no truth, there's no genuine. You can have counterfeit notes and you can have genuine notes so it doesn't have any relevance to whether an intention is where a meaning begins.

Dolan: I think apart from intention another thing to look at is subjectivity and the point is the author as a human subject is obviously more complicated than he knows. I think the distinction for me is whether you are uncovering the subjectivity of the author or looking at the complexity of the text itself. It is not necessarily the same process. You can often get to the text without the author and if you do need to have various foot notes then that can diminish the work.

George: Just very briefly I think if Blake had wanted to write a declaration of love he could have done that. However, instead he wrote The Sacred Rose which includes other elements that are not decoration but intrinsic to the poem. One of the things that Vittorio says which I'm actually very sympathetic towards is that it is a matter of redressing the balance one way or the other. However, somewhere in the Intentist document it says,' When we are in everyday conversation we habitually know our interlocutor's intention without asking for clarification, indeed we become so adept at recognising what others intend their words to mean that misunderstanding surprises us.' It doesn't surprise me. We are constantly listening to each other very hard, to see what are the possible ramifications of meaning and to work out, if you like, the intention. However, we do not know, if we can be certain about it, nor can the speaker be sometimes certain of the effect of their words.

Audience member : First of all, just quickly I love your images about the dance between the writer and language and I think that does point to the important thing about constraints and about art emerging not through a kind of free expression of internal things but through that interplay between intentionality and a mastery of the form; the particular aesthetic form. I think between the interpretation of the reader and the intention of the author is the object itself; is the book itself with the words on the page. However, it's not like other objects obviously- it's a cultural object and so it's meanings and values aren't fixed because it has nuances and emphasises that will change as culture and cultural

values and ideas change themselves. Yet I don't think that means in the Bartesian way that it's limitless because that's to disrespect the truth and what was actually there in the object itself.

Audience member: We do have two fields of study: hermeneutics- interpretation, and semantics the study of meaning and I wonder whether these have become blurred, the result of which is we're so concerned about discovering the meaning we don't see the interpretation to be something firm. Is there a case that to get that interpretation we can draw upon authorial intention meaning and also draw upon many other sources including other readings and critics to get a richer interpretation?

Audience member: This is a question on poetry. I find it quite interesting that George earlier mentioned that he chose a particular word because it rhymes and in that way what I find incredible about art is where in science you ascribe wonder to things you don't really understand, it's precisely because it makes logical sense that you chose a word that rhymes. This is because it's rational because it's determined from the start where your end might be- because it's rational, because you can understand it.

Chair: It's an important point that within Barthes' Death of the Author Barthes gives validation to the Surrealist automatic writing with no constraint of form or intention or whatever.

Audience member: I think five people sitting around a table will see and hear a different person because we are human, we all have different experiences and come from different backgrounds and that's actually something that's very enriching so although I think it's very useful to know the intention of the author, just as an example I think that that term,' We are standing on the shoulders of giants' is significant. We can't create anything without looking at what people have done before you, so my book (not to plug it again) was inspired by a Czech illustrator who died in the 60's and my book yes, is set in different place in New York and not London but it wouldn't have happened if he hadn't written his book before. We need to have that background to be able to go forward.

Audience member: This is a question of balance as I think it is the key question. I was a little confused actually on this question. I think we heard from Vittorio that English faculties are completely saturated in the idea of the death of the author,

but then John told us perhaps differently from his experience. Therefore, I'm wondering what's the real situation? Is it the case that there are different attitudes in England and America? I think it's important in terms of where and how we can begin to think about readdressing the balance.

Audience member: The nature of work is that it is intended to communicate- to communicate through art or through literature and therefore in being 'made' isn't your intention as the maker to communicate something ? Whether that's received in the same way it's intended is a grey area but wouldn't more successful work be work where you receive the intention of the artist?

Chair: In thinking about this question, I think there is sometimes a loss of specificity: we are all readers now, or we're all authors where we used to talk about people being either a painter or a writer or a sculptor or a poet and they were quite distinct things. We can get lost with loosening these categories.

Audience member: When I went to study in the 80s and wanted to talk about Blake etc I was told it was all about discourse. I think one thing that might not have been intended by Barthes is if everything is discourse you are unable to talk about art because you are left with nothing specific.

Audience member: I would like to ask Vittorio about critical judgement. You referred to Bansky. There are several artists that are major personalities, and Banksy would come into that category. Is this something you would be celebrating?

Audience member: I think that the intent of the author is essential when we read literature that is written very far back in history. I agree that with contemporary literature you don't need to know everything about the author because we have common points of reference. However, when you don't have these common points of reference, it can be very difficult to understand the text.

Chair: Thank you. Closing thoughts please from the panel.

Dolan: I take the point about balance and you can go too far with different readings and so on. However, it can be difficult if the subject is a work or art, like a novel or a painting or a poem. There's an exhibition in Florence at the moment curated by Tim Parks about Renaissance painting and it's looking at attitudes to usury. In essence patrons would commission artists to justify the fact that they

were rich and how this was against the teachings of the church. This is interesting because the intentions of the patron are not the same as the intention of the artist. Also, it occurs to me in that vein that one of the intentions of the artist is to make money. So we need to define our intentions- for example, an artistic intention. The last example of this is sometimes we get various people to review plays and sometimes they write excellent material, but if you hire someone who has never been to the theatre to review a play, you will get a piece about what it is like to go to the theatre. So, in conclusion, we need to be precise about what we are judging and how.

George: When Barthes and the other post-structuralists come along you have an outsider's point of view. They are interested in destabilizing the nature of authority. That enters academia but it doesn't enter the popular state that much. So, within the realms of reviews and the outside world, it exists almost independently. I think the interesting thing is that the movement Intentism is a kind of corrective to the kind of idea of the 'blowing up' of the personality of the artist. So Vittorio is trying to correct once more that imbalance which is essentially an academic imbalance. How does academia influence the world outside? It works in subtle, gradual ways. I think some of that influence has been to the good.

Chair: I agree. I think it might be a case of trying to restore or protect the authority of the author.

Vittorio: Just a couple things from a couple of the questions: one was talking about values not being fixed, which was called 'the effective history of the work' by Gadamer. The problem is (and I know that John to my right mentioned Stanley Fish as having one theory out of the impasse with 'interpretative communities'), that any time you have an idea of work having different meanings through culture or public conventions or different people, you are left with the questions: what people? What conventions? What culture? What age? Who are we referring to? We are consequentially left with multiple, perhaps simultaneous, perhaps contrary meanings.

Another question was asked about critical judgement. Intention isn't about truth like Gadamer was concerned with in 'Truth and Method'. Moreover, it's not about appreciation, that's for the art critic. The art critic will judge other areas such as

the quality of your intention. For example, you can realize your intention with a not particularly lofty intention so that is in some respects a separate issue. Intentism is simply about the meaning of the work.

We will never know the intention of an artist or writer omnisciently of course because of our own baggage we take to the work and for many other reasons, but we can know it well enough to understand it.

Lastly, why have we chosen the panel here that supposedly has some sense of authorship or some kind of knowledge in particular areas rather than chat to a friend in the pub? Why are we having a book signing with a couple of people signing books later if authorship doesn't matter and the author has died? This is because authorship, be it a book or a contribution to a panel debate, matters.

John: Very briefly textuality is an incredibly useful academic tool. It should be remembered that Barthes' seminal text that has been alluded to several time 'The Death of the Author' began as a seminar but it seems to me that that utilitarian purpose of putting the author to one side is a very useful and even very necessary way of approaching texts.

Chair: Many thanks to our panel.

Intentist Manifesto
Intentism *noun*
\in-'tentiz?m\

Intentism is a movement of artists, authors, actors and musicians who believe that art *can* convey an artist's intended message to his or her intended audience. As a movement it both recognizes and celebrates the relationship between an artist's creation and its creator.

Intentists believe 3 principles:

1

*Intentists believe that the artist is **free** to convey his or her intended message. Intentists believe that European postmodernism has contributed to **gagging the artist**.*

Eminent poststructuralist Jacques Derrida, seen as a champion of Postmodernism, believes intention, "*...will no longer be able to govern the entire scene and the entire system of utterances.*" For many of Derrida's followers this means that there must **ALWAYS** be more than one interpretation of any text or work. Intention will **NEVER** be completely present. There will **ALWAYS** be undecidables.

Intentism believes in **UNGAGGING** the artist so that he or she can speak to us.

Who is right?

Much of postmodernist art theory claims that the artwork has no universal meaning and can therefore say many things. Meaning rests with the interpreter rather than the artist. If this is true, then the work can mean anything and therefore, effectively mean nothing. NB.

For clarification of Intentist's definition of 'meaning' see *Intentism: Resurrection of the Artist*.

The artist has been gagged.

Much of Postmodernism encourages the belief that no artist or author is able to convey his or her intended meaning because everyone must experience art through their limited frame or reference. Semiotician and social theorist Roland Barthes wrote of *'The Death of the Author'* because, in his eyes, the author's intention is irrelevant. *"To give a text an Author...is to impose a limit on that text."*

Intentists appreciate the revolutionary insights much of postmodernism has made, particularly in the awareness of the baggage every viewer brings to an artwork. However, Intentists believe 'No creative input, no meaning input.' Consequently, a viewer cannot provide a new meaning. Furthermore, since the epistemological qualities of a work finish when the creator creates no more, a viewer can perfectly, but not omnisciently understand the work, since the meaning of the work does not change with each new view. In essence, the hermeneutical circle should be considered the hermeneutical spiral, as a viewer can reduce subjective associations or significances.

Intentists call this the **GAGGING** of the artist because the artist is very much alive and has a message to say.

2

Intentists believe a confused, hidden or denied intention leads to **ZERO** accountability.

This is bad for art and bad for society.
A dead artist can no longer be associated with a painting advocating racism or homophobia, for example. Both Heidegger and Paul De Man have been rightly criticized for writing anti-Semitic articles, which is hypocritical unless an artist's voice can be heard and recognized.

3

Conversely, Intentists believe that an omission of artist intention can lead to enforced **restrictions** on the artist and even censorship.
When the *Contemporary Art Museum* in Cincinatti, opened the art exhibition *The Perfect Moment* in 1990, the city of Cincinnati brought suit against the Centre and two curators as some of the work was considered offensive. The prosecution only showed the work, the defense explained possible artistic intention. The jury acquitted all the accused.
Art has been at the vanguard of changing social behaviour, often encouraging tolerance and civil liberties. Art has often been one step ahead of society in attitudes towards women, race and politics, acting as a social conscience in times of oppression.
The potency of art to speak to the hearts and minds of people is not doubted by dictators who are often keen to silence its voice.
Without the influence of art with a message civilization will be that much more brutal, that much more intolerant.

Intentists believe that although their artwork can have a complex meaning and be understood on a number of levels, there are definitely ways it can be misunderstood - therefore not all interpretations are equally valid.

Intentists believe that their artwork is able to convey their artistic intention to their intended audience.

Intentists believe that the voice of their work is a force for good. Intentists celebrate the 'creative trail' in their work by frequently keeping elements of the editing processes in their work. This layering of ideas we call 'palimpsestism.'

Other Intentism Books available:

Intentism: Resurrection of the Artist

Paperback. Intentism founder Vittorio Pelosi outlines the beliefs of the international art movement.

Includes looking at the difference between meaning and significance and a response to some of Beardsely's (co-author of The Intentional Fallacy) objections.

The Search for Intentist Art

A collection of interviews with contemporary Intentist artists, with contributions from Paisley Livingston and Stephen Carter. Edited by Adrian Haak, Jnr.

Intentism: The interviews 2009-2012

A collection of the leading thinkers about Intentionalism today. Does the author's intention affect the works' meaning? Interviewees include philosophers and practitioners on both sides of the debate.

www.ingramcontent.com/pod-product-compliance
Lightning Source LLC
Chambersburg PA
CBHW070428180526
45158CB00017B/926